Claude Cahun at School in England

by Marcus Williamson

ISBN 978-1-257-63952-6

Copyright © 2011 by Marcus Williamson

All rights reserved. No part of this publication may be reproduced, stored in a retrieval system or transmitted in any form or by any means, electronic, mechanical, photocopying, recording or otherwise, without the prior permission of the author.

Contents

INTRODUCTION .. 1

THE DREYFUS AFFAIR .. 3

ENGLISH CONNECTIONS ... 6

PARSONS MEAD SCHOOL .. 6

PARSONS MEAD MAGAZINE .. 8
 ARTICLES BY AND ABOUT LUCY SCHWOB ... 8
 La Forêt du Gavre - February 1908 ... 9
 Dinner First - March 1908 ... 9
 Histoire d'une vieille barque racontée par elle-même - January 1909 9
 The Visit to Nantes - September 1908 .. 9
 Miscellaneous ... 10

A FORMATIVE YEAR - THE INFLUENCES OF THE SCHOOL 11
 WRITING ... 11
 THEATRE ... 14
 FRENCH LANGUAGE .. 14
 ENGLISH LANGUAGE ... 15

CONCLUSION ... 17

ABOUT THE AUTHOR .. 18

ACKNOWLEDGEMENTS ... 18

APPENDIX A1 - *LA FORÊT DU GAVRE* - PUBLISHED FEBRUARY 1908 IN FRENCH - ORIGINAL FRENCH TEXT ... 19

APPENDIX A2 - *LA FORÊT DU GAVRE* - PUBLISHED FEBRUARY 1908 IN FRENCH - ENGLISH TRANSLATION ... 21

APPENDIX B - *DINNER FIRST* - BY LUCY SCHWOB - PUBLISHED MARCH 1908 IN ENGLISH ... 23

APPENDIX C1 - *HISTOIRE D'UNE VIEILLE BARQUE RACONTÉE PAR ELLE-MÊME* - BY LUCY SCHWOB - PUBLISHED JANUARY 1909 IN FRENCH - ORIGINAL FRENCH TEXT ... 24

APPENDIX C2 - *HISTOIRE D'UNE VIEILLE BARQUE RACONTÉE PAR ELLE-MÊME* - BY LUCY SCHWOB - PUBLISHED JANUARY 1909 IN FRENCH - ENGLISH TRANSLATION ... 27

APPENDIX D - *THE VISIT TO NANTES* - BY JESSIE ELLISTON - PUBLISHED SEPTEMBER 1908 IN ENGLISH ... 30

Claude Cahun at School in England

Introduction

The work and life of the surrealist photographer and writer Cláude Cahun (née Lucy Schwob, 1894-1954) has been rediscovered only relatively recently. It was not until 1980 that the first solo exhibition of her work took place at Galerie Claude Givaudan in Geneva. A monograph by François Leperlier was published in 1992[1], followed in 2002 by a volume of collected writings[2] and a definitive biography, *Claude Cahun - L'Exotisme intérieur*, in 2006. After the death of her partner, Suzanne Malherbe (alias Marcel Moore) in 1972, a group of photographs and archive material came into the possession of the Jersey Heritage Trust, which now holds the largest public collection of her works.

This book provides some newly-discovered information relating to a year Cahun spent at Parsons Mead School, Ashtead, Surrey, England during 1907-1908. This period of Lucy Schwob's life was previously only known about through a brief mention in her autobiographical manuscript material, which we shall examine later.

Lucy Schwob, who adopted the *nom de plume*[3] Claude Cahun around 1918, was born in Nantes on 25 October 1894, the daughter of Maurice Schwob (1859-1928) and Victorine Marie Antoinette Courbebaisse. Maurice Schwob was the owner of the Nantes daily newspaper *Le Phare de la Loire*, having taken over the business from his father George Schwob (1822-1892), who had acquired it in 1876.[4]

As a result of her mother's mental illness Lucy spent much of her childhood with her grandmother Mathilde Cahun (1829-1907), sister of David-Léon Cahun (1841-1900), the orientalist, author of *Introduction à l'histoire de l'Asie*[5] and assistant curator at the Bibliothèque Mazarin, Paris. Lucy's paternal uncle was the symbolist writer and journalist

[1] François Leperlier, *Claude Cahun. L'écart et la métamorphose* (Jean Michel Place, 1992).

[2] François Leperlier (ed.), *Claude Cahun - Ecrits* (Jean Michel Place, 2002).

[3] Other names she is known to have used include Claude Courlis and Daniel Douglas.

[4] For background information on the Schwob family see Patrice Allain, *La Famille Schwob - Des lettres de la République à la République des Lettres*, in *Europe* (May 2006), p. 32 et seq.

[5] Léon Cahun, *Introduction à l'histoire de l'Asie* (Armand Colin, 1896).

Marcel Schwob (1867-1905), author of works including the novels *Coeur Double* and *Vies Imaginaires*.

The review of the trial of Captain Alfred Dreyfus, in 1906, brought the *Affaire Dreyfus* back into the public consciousness, resulting in an upsurge of anti-semitism in France. This was despite the 1905 law - itself partly a consequence of the Dreyfus Affair - which had established secularism (*laïcité*) within France, formally separating the church and state.

This was a significant epoch in Lucy Schwob's life, as it combined a number of elements including: an enforced exile, caused by anti-semitic attacks at her school in Nantes; it was the first time that she had been away from home for any length of time on her own; as a school exclusively for girls, Parsons Mead provided her with the opportunity to develop further as a woman amongst women, away from male influences; finally, and perhaps most importantly for her as an embryonic writer, it gave her the possibility to develop her creativity, both as part of the school curriculum and in extra-curricular literary activities.

The Dreyfus Affair

Captain Alfred Dreyfus (1859-1935), a former schoolmate of Maurice Schwob, was arrested on 15 October 1894 on charges of spying for Germany, based on documents which were later shown to be forgeries. He was court-martialled on 19 December 1894 and sent to the notorious prison on Devil's Island in January of the following year.

On 13 January 1898 Émile Zola published his famous article *J'Accuse...!* in the newpaper *Aurore*. The article, in the form of an open letter addressed to President Félix Faure, accused the Dreyfus court-martial, and others involved in the case, of violating the law. Marcel Schwob wrote frequently and sympathetically about the Dreyfus case in his *Lettre parisienne* column in *Le Phare de la Loire*[6] during 1897-1898. He would, under normal circumstances, have naturally been a 'friend' of Zola's cause. However, Schwob's dislike of Zola and his work meant that he could not bring himself to sign a manifesto supporting Zola, who was brought to trial for criminal libel, as a result of the Aurore article.[7]

In June 1899 Dreyfus was declared innocent and on 19 September of the same year he received a pardon from the newly-elected President, Émile Loubet. Following a review of the trial, on 12 July 1906 Dreyfus was exonerated by the court, pardoned and subsequently rejoined the French army.[8] The review of the trial triggered a resurgence of anti-semitism in Nantes, directed particularly against the Schwob family, whose outspoken views on the Dreyfus Affair were evident from the editorials of the openly Republican *Le Phare de la Loire*. Speaking of the campaign against Dreyfus, Pierre Birnbaum observes:

> "According to the superintendent, the members of the league [Ligue Antisémite] launched a "relentless campaign against the influences of the Jewish colony, so powerful in Nantes." and benefited from the considerable support of several newspapers, which published vengeful press releases. They were combatted

[6] See Monique Jutrin, *Un chroniqueur de l'affaire Dreyfus*, in *Europe* (May 2006), pp. 78-87.

[7] "L'animosité de Schwob est telle qu'il refusera de signer le manifeste de soutien à Zola au moment de l'affaire Dreyfus", Marguerite Cahun, *Le Cousin Marcel*, in *Europe* (May 2006), p. 58.

[8] In July 2006, on the 100th anniversary of the 1906 trial, President Jacques Chirac issued a decree formally absolving Dreyfus. It had taken 100 years for his name finally to be cleared.

explicitly only by *Le Phare de la Loire*, whose editor, Maurice Schwob, became the target of the local anti-semitic movement."[9]

Although the *Phare* was in theory just a provincial newspaper, it had a distribution and influence far beyond its local area, as suggested by Claude Cahun, writing about her father in *Confidences au Miroir*:

> "Malgré l'indignation de ma grand-mère, qu'il vénérait, il envisagea même l'affaire Dreyfus sous l'angle national... Je ne doute pas qu'à la place du capitaine il eût courbé la tête, péri "déshonoré"...à l'île du Diable."[10]

Explaining the difficulties of this period of Lucy Schwob's life, François Leperlier quotes a long, autobiographical letter she wrote to Charles Henri Barbier in 1951:

> "Au moment de la révision du procès (1905-1906), Lucy est directement exposée aux persécutions de quelques camarades. En juillet 1907, les choses s'aggravent "Un jour, liée avec des cordes à sauter à un arbre de la cour de récréation, je fus lapidée avec du gravier.""[11]

For Lucy this time would represent the first occasion when she had been persecuted for being different, in being part of a family of Jewish supporters of the Dreyfus cause in the midst of an atmosphere of *anti-Dreyfusard* hysteria. Although she does not write of the Affair in *Parsons Mead Magazine*, it must surely have acted as a catalyst for her political thought and writing in her later life as a surrealist and revolutionary activist.[12] Elie Wiesel, who chairs the Support Committee of the Zola-Dreyfus museum, suggests that this was one of the positive

[9] Pierre Birnbaum, *The Anti-Semitic Moment - A Tour of France in 1898* (Hill and Wang, 2002), pp. 241-242.

[10] *Confidences au Miroir* in Leperlier, *Ecrits*, p. 600: "In spite of the indignation of my grandmother, whom he adored, he even envisaged the Dreyfus Affair from a national perspective... I do not doubt that he would have taken the Captain's place and perished "dishonoured"... on Devil's Island." [translation MW]

[11] François Leperlier, *Claude Cahun, L'Exotisme intérieur*, p. 27: "At the time of the review of the trial (1905-1906), Lucy was directly exposed to attacks from some schoolmates. In July 1907 it got worse "One day, tied up with skipping ropes to a tree in the playground, I was pelted with gravel."" [translation MW]

[12] Claude Cahun was a member of the Fédération Internationale de l'Art Révolutionnaire Indépendant (FIARI), a left-wing and anti-Stalinist group, during her time in Paris and remained a member after moving to Jersey. She was a signatory to the FIARI declaration *A bas les lettres de cachet! A bas la terreur grise* published in June 1939.

outcomes of the Affair, in making people act together in the face of political adversity, towards the common good:

> "The Dreyfus Affair will remain a great moment in the history of France. It galvanised men and opened them to fraternity. With the Affair, "intellectuals" considered themselves committed. With the Affair, it became clear that the fight for humanity always comes down to a fight for an individual."[13]

Faced by the attacks on his daughter, Maurice Schwob decided to withdraw her from school in Nantes and sent her to board at Parsons Mead School, in England, where she remained for one school year. She rejoined the girls' school at Nantes in September 1908[14], by which time the Dreyfus Affair had largely blown over.

[13] http://www.maisonzola-museedreyfus.com/uk/interview_1_uk.html [Accessed 22 February 2009]

[14] Leperlier, *Claude Cahun, L'Exotisme intérieur*, p. 28.

English Connections

The Schwob family already had links with England. Marcel Schwob was an anglophile who had translated works by Robert Louis Stevenson and Shakepeare's *Hamlet* for the French audience during the 1880s and 1890s.[15]

Marcel married Marguerite Moreno (Monceau) on 12 September 1900 in England. He stayed at the house of the author Charles Whibley (1859-1930) in Haslemere, Surrey during August and September, prior to the wedding.[16] It is possible that Whibley would have made the recommendation of Parsons Mead, located only some 30 miles away and also in Surrey. Moreover, Lucy's brother, Georges, had just completed part of his schooling in England, so it would not have seemed particularly unusual for her to follow him across the Channel for her education.[17]

Parsons Mead School

Parsons Mead School was established in May 1897 at Ashtead, Surrey, by Jessie Elliston (1858-1942) as a "high-class Boarding and Day School for the daughters of Gentlemen"[18] with the objective of producing "Simple-hearted girls who will develop into noble women, honourable and true".[19]

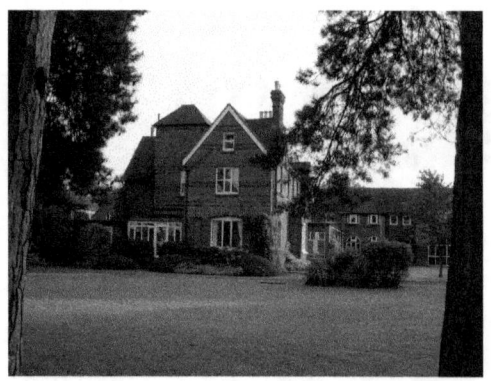

Parsons Mead School
Photo courtesy of Barbara Dawson

[15] Marcel Schwob's first article on Stevenson appeared in *Le Phare de la Loire* on 27 August 1888.

[16] See John Alden Green (ed.) *Marcel Schwob - Correspondance Inédite* (1985).

[17] Leperlier, *Claude Cahun, L'Exotisme intérieur*, p. 28.

[18] Barbara Dawson, *An Act of Faith - 100 Years of Education at Parsons Mead School*, p. 6.

[19] *Ibid.*

The school's motto was "Nulla dies sine linea", a quotation taken from Pliny's *Historia Naturalis* and meaning "Not a day without a line", a term which could refer equally to drawing or to writing, but in this context almost certainly refers to the written word.

The school admission and attendance records from this time are no longer extant. However, the periodical produced by the school, *Parsons Mead Magazine*, contains valuable traces of her presence and work by her or relating to her, as well as details of the school's activities in general.

Furthermore, we are fortunate that the occasion of the 1997 centenary of the school saw the publication of a detailed history, *An Act of Faith - 100 Years of Education at Parsons Mead School* by Barbara Dawson, a member of the school staff. In July 2006, one year before its 110th anniversary, the school was forced to close, due to a lack of funding.[20]

Other notable Parsons Mead "old girls", whose lives are outlined in *An Act of Faith*, include the writer Anna Kavan (Helen Woods, 1901-1968), Stella Cunliffe (b. 1917), former Director of Statistics at the British Home Office and the artist Joan Hassall (1906-1988).

[20] The school and its grounds have since been acquired by a property development company which intends to demolish the school and build houses in its place.

Parsons Mead Magazine

Parsons Mead Magazine was a periodical by and for the pupils of Parsons Mead school, which was first published in 1905. During the years between 1905 and 1923 just one unique example of each magazine was created, including handwritten text, original artwork, photographs and postcards. For most of that period (1905-1920) it was usually Edith Rowe, Head of Staff, whose handwriting could be found across its pages. The magazine would typically consist of news from the head teacher, reports of activities which had taken place (such as plays, sports days and prize giving), birthdays for the month and articles by pupils. The articles would include written material - both non-fiction and fiction - as well as photographs, postcards and artwork by the students.

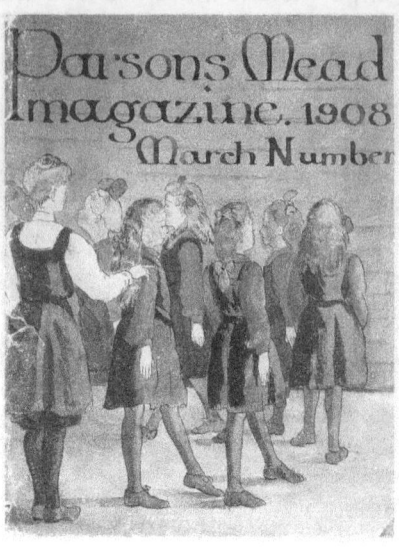

Cover of *Parsons Mead Magazine*

The *Old Girls' Magazine* - a distinct and separate edition of the magazine - was first published in January 1909, a few months after Lucy Schwob had left. This periodical was intended as a way to reach out to former pupils (known as the "old girls") of the school. The magazine contained a circulation address list, allowing former pupils to stay in contact and so that the current recipient could know to whom the magazine should next be sent[21].

Articles by and about Lucy Schwob

There are three articles by Lucy Schwob in *Parsons Mead Magazine*, one article by the head teacher, telling of a visit to Nantes to see her and her family, and some miscellanous items relating to her time at the school. The articles are:

[21] See, for example, *Parsons Mead Magazine* for August 1909, which contains the Nantes address of Lucy Schwob as : "13 Rue du Commerce, Loire Inferieur, Nantes". It is perhaps worth noting that the address shown in the article *The Visit to Nantes* is "12 Place du Commerce".

- *La Forêt du Gavre* by Lucy Schwob - February 1908[22]
- *Dinner First* by Lucy Schwob - March 1908[23]
- *Histoire d'une vieille barque racontée par elle-même* by Lucy Schwob - January 1909[24]
- *The Visit to Nantes* by Jessie Elliston - September 1908[25]
- Miscellaneous

La Forêt du Gavre - February 1908

A documentary piece, written by Lucy Schwob in French and illustrated with eleven postcards. The article describes the forest of Gavre, 40km from Nantes, where she enjoyed spending time with her family. The article describes the location and layout of the forest, how the family would travel there, the games they would play and other visitors to the forest, including charcoal makers and mushroom hunters.

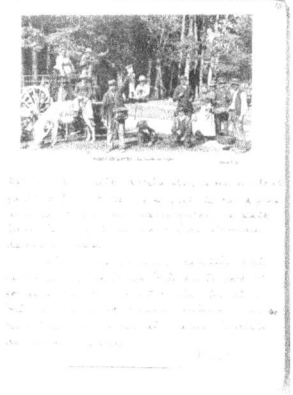

La Forêt du Gavre from Parson's Mead Magazine

Dinner First - March 1908

A short story by Lucy Schwob, written in English, consisting of just two pages of handwritten text. In the story a boy and his father are travelling to market with a hay cart. The cart overturns and the father is buried under the hay. The boy goes to fetch help and finds a farmer eating his lunch. When they return to the location of the accident the father is no longer there, so the boy returns home. He finds his father, who jokes that it is now time for dinner.

Histoire d'une vieille barque racontée par elle-même - January 1909

A short story by Lucy Schwob, written in French, which relates the tale of a small boat, washed up on the shore, telling its life history.

The Visit to Nantes - September 1908

An illustrated documentary piece in English, written by the school founder and head teacher at the time, Jessie Elliston, describing her

[22] Surrey History Service 8091/8/17
[23] Surrey History Service 8091/8/18
[24] Surrey History Service 8091/8/22
[25] Surrey History Service 8091/8/20

visit to Lucy Schwob's home at 12 Place du Commerce, Nantes, accompanied by Laurette Elliston, a member of her family.

Here, Jessie Elliston describes the journey to Nantes by ship and train, the Schwob house and library, a trip to a La Forêt du Gavre, exploring the town of Nantes and a visit to a biscuit factory.[26]

Miscellaneous

October 1907

In this edition we find a list of "Birthdays for the month", including "October 25: Lucy Schwob", who would celebrate her thirteenth birthday on that day.

September 1908

Prize Day - including the following prizes to Lucy Schwob, presented by "Lady Robert Cecil"[27]:

- English
- Swimming
- Royal Drawing Society Division I Passed
- Royal Drawing Society Division II Honours

The Royal Drawing Society was an educational body, established in 1888 and incorporated in 1902, whose aim was "the teaching of drawing as a means of education"[28], based on the concept that very young children could often draw - and therefore express themselves in that way - even before they could write.

August 1909

Name and address list, including Lucy Schwob:
"13 Rue du Commerce, Loire Inferieur, Nantes"

[26] This would have been either Lefèvre-Utile (LU) or La Biscuiterie nantaise, two rival *biscuiteries* in Nantes.

[27] Lady Eleanor Lambton (1868-1959), wife of Lord Robert Cecil (1864-1958), Member of Parliament (MP) for Marylebone East during the period 1906-1910.

[28] http://www.1911encyclopedia.org/Art_societies
[Accessed 22 February 2009]

A Formative Year - The Influences of the School

Writing

It is clear from her biography that Lucy Schwob already had a passion for language and for writing prior to her arrival at Parsons Mead. A letter from Mathilde Schwob to her son Marcel speaks of little Lucy ("Lucette"), then only 6-years old, and her "astonishing intelligence":

> "Lucette voyant que je me dispose à t'écrire m'a tourmentée tellement que j'ai consenti à lui commencer ma lettre. C'est un enfant étonnante d'intelligence: si on ne l'arretait pas elle écrirait des pages sans faire des fautes, pour ainsi dire."[29]

Equally evident is that the school encouraged the development of writing skills and, through curricular and extra-curricular work (in *Parsons Mead Magazine* for example), gave outlets for literary creativity. As we saw earlier, "Nulla dies sine linea" provided both a motto and what we might call today a "mission statement" for the school, putting writing at the core of its activities. One can imagine Lucy's father, Maurice Schwob, a publisher and man of letters, being well aware of this emphasis when making his decision about the choice of a suitable school for his daughter.

Lucy Schwob's written work of this time shows two particular themes which reappear in her later work. In the piece *Histoire d'une vieille barque racontée par elle-même* (published in 1909 after her return to Nantes) this sentence

> "Construite à St. Nazaire, j'eus le Croisic pour port d'attache."

prefigures an illustration by Marcel Moore (Suzanne Malherbe) to be found in *Vues et Visions*[30], showing two boats bearing the inscription "Le Croisic", indicating their home port, together with the text:

[29] 8 July 1901, quoted in Leperlier, *Claude Cahun, L'Exotisme intérieur*, p. 52: "Lucette, seeing that I am about to write to you, tormented me so much that I agreed to allow her to start my letter. This is a child of astonishing intelligence: if one doesn't stop her she would write pages without making any mistakes, as such." [translation MW]

[30] See p. 74 of *Vues et Visions* (p. 96 of *Ecrits*) - The work was published as text in 1914 in the review *Mercure de France* then as a book in 1919, illustrated by her stepsister and partner Marcel Moore (Suzanne Malherbe).

> "A l'arrière des lettres blanches attirent mes regards. Je cherche à lire... l'inscription à demi effacée ne m'apprend rien, sinon que le Croisic est leur port d'attache à tous deux."[31]

Le Croisic (where the Schwob family holidayed), the Isle of Yeu (home of Lucy Schwob's friend Marc-Adolphe Guégan) and Jersey, where Lucy Schwob and Suzanne Malherbe visited and later chose to live, were all maritime locations where ships and boats of all types would be commonplace.

The idea of a "home port" (port d'attache) occurs again in *Vues et Visions*:

> "Retour au port d'attache"

The period of 1905-1908 was a difficult one in her life, with the already-mentioned Dreyfus Affair, the death of her Uncle Marcel (1905) and of her Grandmother Mathilde (1907), together with the resulting issues of succession for her estate. One can imagine that for Lucy Schwob the idea of a "home port" represented a safe place - a place of anchor - in a life which had already seen upheaval and which had been somewhat nomadic.

Significantly, perhaps, the 1909 piece relates to a single boat whereas the 1919 illustrations depict two boats on one page, faced on the opposite page by two androgynous-looking stone human figures. By this latter date Lucy Schwob and Suzanne Malherbe were living together as lovers. The text continues, repeated on the left and right pages, affirming at the same time the togetherness of the two boats and of the two figures, "...brothers, they sleep together, and death unites them forever.":

> "Jamais nul ne saura leurs noms sans gloire, et cependant je rêve à leur destin qui m'apparaît calme et doux : frères, ils dorment ensemble, et la mort les unit à jamais."

[31] "At the back white letters draw my attention. I try to read... The half-erased lettering does not tell me anything, except that le Croisic is the home port of both of them." [translation MW]

Illustrations by Suzanne Malherbe from *Vues et Visions* (1919)

The second theme we shall look at is the concept of inanimate objects mentioned in *Histoire d'une vieille barque* in this context:

> "Il me prenait pour une chose inanimée, privée de toute intelligence et de tout sentiment..." [32]

Again in *Vues et Visions*, published ten years later, we see a similar concept expressed:

> "Les objets inanimés ont pourtant leur âme obscure, ignorée des humains..."[33]

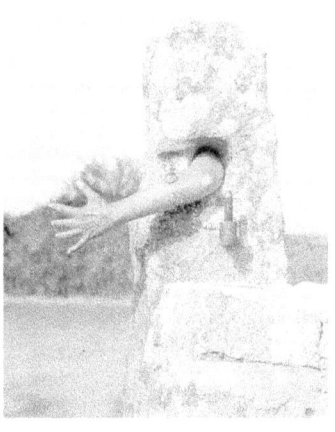

Both the younger and adult Lucy seem to have considered that inanimate objects - such as the boat in her story - would have their own soul, of which humans are unaware. This theme is further echoed in her photograph *I Extend my Arms* (1931/32) where an inanimate object, a large stone, is made animate by a human arm protruding through an

I Extend my Arms (1931/32)

[32] "He thought of me as an inanimate object, with neither intelligence nor feeling..." [translation MW]

[33] See p. 66 of *Vues et Visions* (p. 88 of *Ecrits*): "However, inanimate objects have their hidden soul, of which humans know nothing..." [translation MW]

aperture in the stone. The artist Elizabeth Manchester, in a commentary on this photograph, says:

> "It is clearly a performative photograph in which the artist could be said to be 'wearing' the rock as a mask or costume; at the same time the photograph anthropomorphises an inanimate object."[34]

Theatre

Miranda Welby-Everard's article, *Imaging the Actor: the Theatre of Claude Cahun*[35], was the first work to examine in depth the role of theatre in the life of Claude Cahun. It is likely that Lucy Schwob's fascination with theatre and performance was first engendered by her time at Parsons Mead, which had a strong tradition of what the school's founder called "putting on a play". Barbara Dawson explains:

> "The tradition for exciting and varied dramatic productions has been an important part of life at Parsons Mead throughout its 100 year history..."[36]

> "As with pieces for the school magazine, the world of mythology, morality and fairyland were favourite subjects for plays, often combining all three elements."[37]

French language

The teaching of the French language was a significant element of the curriculum at Parsons Mead, as Jessie Elliston, the head teacher observed in the school magazine:

> "Every girl in the school must remember that great importance is attached to French. The language should be spoken quite freely, and would be if there was any desire to make real progress. One thing is certain - an English girl who thoroughly masters French is

[34] http://www.tate.org.uk/servlet/ViewWork?workid=93566&tabview=text [Accessed 22 February 2009]

[35] *Imaging the Actor: the Theatre of Claude Cahun*, Welby-Everard, Oxford Art Journal.2006; Volume 29.

[36] *An Act of Faith*, p.107.

[37] *An Act of Faith*, p.108.

never likely to regret it, but on the other hand will always be glad of it."[38]

Lucy Schwob would naturally have had fluent French already and the presence of a native French teacher at the school would mean that there would be no danger of losing her language during the time away from her home country.

English Language

The head teacher, Jessie Elliston, visited Nantes with Laurette Elliston. She describes Lucy Schwob's home in the building of the *Phare de la Loire* on the Place de Commerce and its "...immense library with a splendid collection of English, French and German books". One can imagine the young Lucy browsing the library and reading works in all three languages, even before arriving at Parsons Mead.[39]

As we saw earlier, Lucy Schwob had received an award for English during the school's 1908 Prize Day. She wrote of this prize in her 1951 autobiographical letter to Charles Henri Barbier:

> "J'avais si vite appris l'anglais que j'avais eu le prix de littérature".[40]

Ten years later her excellent knowledge of the English language would be demonstrated in the article *La 'Salomé' d'Oscar Wilde. Le procés Billing et les 47000 pervertis du Livre noir* published in the review *Mercure de France* under the name Claude Cahun. She reports on the infamous libel case brought by Maud Allan - who staged a production of Wilde's play - against Noel Pemberton Billing, a member of parliament. Here she is able to exercise her expertise in the English language and literature, as well as for the life and work of Oscar Wilde, in bringing the news of the case to the francophone public, as she explains to *Mercure de France* readers:

[38] February 1907 editorial from *Parsons Mead Magazine* quoted in Dawson, *An Act of Faith*, p.7.

[39] She and Suzanne Malherbe would much later, during the occuption of Jersey in the 1940's, use their knowledge of German to compose sophisticated subversive messages against the occupying troops. They would sign their messages with the code name *Der Soldat ohne Namen* [The soldier with no name].

[40] Quoted in Leperlier, *Claude Cahun, L'Exotisme intérieur*, p. 28: "I had learned English so quickly that I received the prize for literature." [translation MW]

"Je rapporterai, en les traduisant littéralement, les parties de l'interrogatoire qui ont trait au côté littéraire du procès et à la vie privée d'Oscar Wilde."

Then, in 1929, and emulating her uncle Marcel Schwob, who brought English literature to France, Lucy Schwob (credited on the cover as "Lucie Schwob") produced the French translation of *L'Hygiène sociale - I - La Femme dans la Société* by the sexologist Havelock Ellis (1859-1939).

A year later we see in *Aveux non Avenus* (1930) the use of clever wordplay and puns in French and English, which again owed their debt to Lucy's early exposure to written and spoken English at Parsons Mead. On pages 120-121, for example, we see a short dialogue between the actors in a playlet, in which Claude Cahun switches effortlessly and fluidly between French and English.

Conclusion

As we have seen, the time in England at Parsons Mead had a significant impact on the life of Lucy Schwob. After being taken away from Nantes because of difficult times in her home town, the one school year abroad was evidently "...beneficial in every respect - her studies were excellent and her health and self-confidence were renewed".[41]

The newly-discovered extracts from *Parsons Mead Magazine* represent the earliest known examples of Lucy Schwob's written work and provide precious nuggets of information about her year at the school. They show her to have been a very capable, prize-winning student who was writing fiction and non-fiction documentary material in both English and French from an early age.

Whilst she is now still best known as a photographer, we see her here as being a strong, independent young woman who was already addressing existential questions in her written work. Her time in England at Parsons Mead served her admirably for the literary and artistic future life ahead.

[41] Leperlier, *Claude Cahun, L'Exotisme intérieur*, p. 28 [translation MW]

About the Author

Marcus Williamson is an independent researcher with a passion for the women of surrealism. He writes obituaries for *The Independent* and has recently published *The True Celtic Language and the Stone Circle of Rennes les Bains*, a translation of the 1886 work by Abbé Henri Boudet. He is currently researching Claude Cahun's involvement with the world of silent film in the 1920s. Some examples of his writing can be found on this blog:

http://marcuswilliamson.blogspot.com

Acknowledgements

I would like to express my gratitude to Barbara Dawson for her enthusiastic assistance in providing copies of Parsons Mead Magazine and for her labour of love *An Act of Faith - 100 Years of Education at Parsons Mead School*. Thank you also to the staff of Surrey History Centre, and especially to Margaret Griffiths, who catalogued the Parsons Mead School archive. I am also very grateful to Tirza True Latimer for her constructive input into the structure and content of this article and for her own insightful studies of the life and work of Claude Cahun.

Appendix A1 - *La Forêt du Gavre* - Published February 1908 in French - Original French text

La forêt du Gavre est une de plus grandes et des plus belles que je connaise. Elle a environ 5000 hectares et de grandes avenues qui ont plus de 15 kilomètres de long. Quoique le pays soit assez plat elle n'est pas monotone parceque plusieurs petits cours d'eau la traversent et surtout à cause de la grande variété des arbres qui changent à chaque instant son aspect.

On y trouve surtout d'admirables chênes, des sapins, des hêtres, des trembles et des bouleaux.

Elle est à 40 kilomètres de Nantes et tout près d'un gros bourg nommé Blain. Nous y allons en automobile et il nous faut une heure à peu près pour atteindre le rond point d'où partent sept belles routes comme les rayons d'une étoile.

Je ne sais vraiment pas si la fôret est plus belle en été ou en hiver, en hiver elle est mélancholique et imposante. En été nous emportons souvent à déjeuner, nous nous étendons sous les arbres et nous faisons un délicieux pic-nic.

Après le repas nous faisons des parties interminables de cache-cache, de quatre coins ou de collin-maillard avec de grands éclats de rire quand le pauvre aveugle attrape un arbre ou un bouisson au lieu d'une personne.

Nous nous déchaussons et nous nous amusons follement à poursuivre les petits poissons dans un charmant ruisseau que nous préférons à tous les autres et qui serpente à travers les sites les plus jolis: ou bien nous essayons de construire un moulin avec des palettes en bois qui tournent sous l'effort du courant.

En hiver nous allumons un grand feu de joie sur la route devant le ruisseau à un endroit où on ne risque pas de mettre le feu à la fôret et nous dansons une ronde autour tandis que de bonnes pommes de terre cuisent sous la cendre. Elles sont exquises avec leur enveloppe brûlée et un peu de beurre frais acheté au village. Nous faisons de feu avec du bois mort ramassé dans la forêt et des fougères sèches. Comme le bois est un peu mouillé, nous creusons un petit trou dans la terre, nous y mettons un chiffon que nous arrosons d'essence. Mais il faut être prudent et jeter l'allumette de loin, cela fait une petite explosion. Souvent, pendant ce temps, nous entendons sonner du cor et aboyer les chiens. Ce sont ls chasseurs qui lancent un daim ou, parfois, un

beau cerf, qu'on voit traverser les allées comme une flêche avec toute la meute à ses trousses. Cela nous fait de la peine. Il est défendu de chasser les biches, mais il y a de méchants braconniers qui le font tout de même. Personne n'habite la fôret, excepté les charbonniers qui y font des huttes près de leurs tas de bois. Ils sont très curieux à visiter et très aimables. Il y a aussi les sabottiers qui avec de beaux troncs d'arbres bien choisis font de jolis sabots qui se vendent dans tout le pays.

Souvent aussi on rencontre dans la fôret des chercheurs des champignons. Ceux-ci ont une grande réputation de finesse, mais il faut être très prudent et connaître les bonnes espèces pour se risquer à faire une cuillette. Nous aimons mieux nos pommes de terre sous la cendre: c'est plus sûr.

Quand nous les avons mangées, et que la nuit arrive, nous nous mettons en route pour rentrer et nous allumons nos grands phares à acétylène qui éclairent la route à plusieurs centaines de mètres.

Le voyage de retour à travers la nuit est tout à fait agréable, avec un tout petit élément de peur qui le rend plus amusant encore, parce qu'on ne sait jamais ce qui va sortir de l'ombre devant vous.

Enfin nous sommes rentrés, gais et contents, les joues brûlantes par le souffle du bon vent froid. On dîne bien et on dort encore mieux. On se réveille le lendemain avec le désir de recommencer.

Lucy Schwob

Appendix A2 - *La Forêt du Gavre* - Published February 1908 in French - English translation

The Gavre forest is one of the largest and most beautiful that I know. It is about 5000 hectares in size and has large avenues which are more than 15 km in length. Whilst the countryside is fairly flat it is not monotonous, as several small water courses cross it and above all because of the great variety of trees which change its appearance at each moment.

One mainly finds there impressive oaks, pines, beech, aspen and birch.

It is 40 km from Nantes and very close to a large town called Blain. We go there in the car and it takes nearly an hour to reach the roundabout, from which seven roads lead off like the rays of a star.

I don't really know if the forest is more beautiful in summer or in winter, in winter it is melancholic and imposing. In summer we often take lunch, relax under the trees and make a delicious picnic.

After the meal we play endless games of hide-and-seek, "quatre coins" or "collin-maillard" with great outbursts of laughter when the poor blind one catches a tree or a bush instead of a person.

We take off our shoes and amuse ourselves wildly in chasing the little fish in a charming stream, which we prefer to all the others and which snakes across the most beautiful areas: or we even try to build a mill with wooden palettes which turns with the help of the current.

In winter we light a large bonfire on the road in front of the stream at a place where there is no danger of setting light to the forest and we do a circle dance around it whilst the good potatoes cook in the cinders. They are exquisite with their skins burnt and a bit of fresh butter bought in the village. We make the fire with dead wood gathered in the forest and with dry ferns. If the wood is a bit damp: we dig a small hole in the earth and we put into it a scarf doused in petrol. But one must to be careful to throw the match far away, as it makes a small explosion. Often, at this time, we hear the sound of the hunting horn and the barking of the dogs. These are the hunters who chase a deer or sometimes a fine stag which one can see crossing the paths like an arrow, with all the crowd at its heels. This upsets us. It is forbidden to hunt deer, but there are poachers who do it all the same. No-one lives in the forest, apart from the charcoal-makers who make their huts near their wood-piles. They are very interesting to visit and very

friendly. There are also clog-makers who, with well-chosen tree trunks, make pretty clogs which are sold in all the surrounding area.

Often one also meets mushroom hunters in the forest. They have a great reputation for their quality, but it is necessary to be very careful and know the right species when taking the risk of collecting them. We prefer our potatoes in the embers: they are safer.

After we have eaten them and night falls we set off to return home and light our large acetylene headlights which illuminate the road for several hundred metres ahead.

The return journey at night is very pleasant, with a small amount of fear, which makes it even more entertaining, as one never knows what will come out of the shadows in front of you.

Finally we are back, gay and happy, cheeks burning from the cold wind. We eat well and sleep even better. We get up the following day with the desire to do it all over again.

Lucy Schwob

Appendix B - *Dinner First* - by Lucy Schwob - Published March 1908 in English

One day it chanced that a man and his son were taking a load of hay to the market. The father was driving and the boy was walking at the side. Suddenly the cart went over a stone; the father fell on the road and the hay was upset over him. There was a farm-house near the road; the boy ran to it to fetch some help. It was 1 o'clock and the farmer was eating his dinner.

The boy told his story, forgetting only to say that his father was under the hay. The farmer asked him to stay and have some dinner with him. After dinner the farmer said,

"Don't you think it has been better to dine first and work afterwards?"
"Yes", replied the boy, "but my father will not like it."
"Why?"
"Because he is under the hay."

The farmer was so surprised that he could not speak for a few minutes; at last he said:

"Is he very much hurt?"
"I don't know," said the boy.
"We had better be quick and find out then; he may be dead by this time."

When they arrived at the place where the accident had happened, what do you think they found? Nothing!

The cart had disappeared, the hay had disappeared, the father had disappeared.

"Your father must be home," said the farmer, "if you like, I can drive you back, it is a long way."

When the boy got home his father was there, and listened to his story. Instead of getting angry, he laughed and said,

"Now come and have a good tea, there is nobody under the hay this time, and we will all do our work better afterwards."

L. Schwob

Appendix C1 - *Histoire d'une vieille barque racontée par elle-même* - by Lucy Schwob - Published January 1909 in French - Original French text

Je passe, presque tous les ans, une partie des grandes vacances au bord de la mer. Ma grand' mère a, dans un charmant îlot de l'Atlantique, une grande propriété "Le clos Yvon". Là, nous nous retrouvons chaque année, mes cousines et moi. L'été dernier j'y restai plus longtemps que d'habitude et l'on peut deviner que je ne m'en suis pas plainte.

Pendant la première quinzaine d'Août, la chaleur avait été accablante; les racquettes de tennis restaient à la maison, mais en revanche les costumes de bain n'y restaient pas. Nous passions tout notre temps à la pêche et sur la plage. Dans une anse entourée de rochers nous avions découvert une vieille barque dont la quille était profondément enforcée dans le sable. Elle devait être là depuis la derniere tempête et aucune fureur de l'océan ne pouvait maintenant l'ébranler.

Souvent nous avions cherché à savoir d'où elle venait mais les pêcheurs ne savaient rien......

Nous jouions depuis longtemps et, fatiguées, nous nous étions assises sur le bancs de la chaloupe. Nous avons posé notre goûter dans une petite niche à l'avant, je l'en retirai et je vis, coinsée entre deux planchers, une feuille de papier pliée soigneusement et recouverte d'une toile goudronnée. Cela expliquait pourquoi elle n'avait pas été détruite par la mer.

Je la dépliai et lus cette phrase écrite par la main d'un enfant: "Ma chère petite barque, ma Mignon, adieu." On voyait encore sur le billet comme des traces de larmes; de l'eau de mer seulement, sans doute.

"<u>Mignon</u>" était evidemment le nom de la barque; on pouvait encore le diviner sur la plaque de cuivre à l'avant du canot.

Etendues sur le sable à l'ombre de la chaloupe, nous fûmes en vain des suppositions pour expliquer la provenance du billet. Peu à peu mes idées se brouillèrent, il me sembla que j'étais seule, bien loin et que j'entendais la barque qui parlait:

"O vous, grands flots bleus qui m'avez vus naître, qui m'avez tout donné et qui m'avez tout pris, écoutez mon histoire car je vais mourir, plus tard tous la redirez aux poissons qui nagent dans vos profondeurs, aux oiseaux qui planent au dessus de vous, et aux jeunes barques qui

glissent à votre surface. Je suis vieille, usée, finie, et cependant il fut un temps où j'étais la plus belle chaloupe de mon domaine, l'océan! Construite à St. Nazaire, j'eus le Croisic pour port d'attache. Nul ne pouvait me devancer quand j'étais conduite par un habile pilote. Malgré ma fragilité j'étais si légère à la lame et si obeissante à mon gouvernail qu'on pouvait sans imprudence affronter les vagues du large avec moi.

Un marin anglais m'acheta et je fis avec lui de grands voyages; il me soignait bien et je le servais de mon mieux, mais je ne l'aimais pas. Pourquoi? me direz vous: Il me prenait pour une chose inanimée, privée de toute intelligence et de tout sentiment et me soignait simplement parce que je valais de l'argent.

Au bout de cinq ans malgré ses soins, la rouille s'empara de moi et il pensa qu'il était temps de me vendre et de me remplacer par une camarade plus jeune et plus jolie. Nous étions près des rivages de France, non loin d'ici et comme nous allions nord-ouest j'espèrais revoir mon pays natal que je pleurais souvent.

Mon espérance ne fut pas trompée, après deux jours de voyage nous atteignîmes le Croisic. Ma joie est impossible à dépeindre! Je retrouvai une de mes ancienne amies et nous pûmes parler ensemble, du passé.

Peu de temps après notre arrivée, j'appris que j'étais vendue à une riche propriétaire des environs. Vous dire ma joie est superflu. Bientôt je vis mon maître qui me plut au premier abord ainsi que son fils, un blondinet de sept ans. Le dernier n'eut bientôt de plus grand plaisir qu'une promenade en mer en tenant mon gouvernail sous la surveillance de son père. Cher petit Maurice! Je vécu ainsi heureuse pendant trois ans, mais le bonheur ne peut durer toujours, mon maitre dut partir, et malgré les prières du petit Maurice on ne put m'emmener.

Ils devaient aller à un endroit "où il n'y a pas de mer" disait le papa. Maurice pleura, car il m'aimait sincèrement, et je joignis mes larmes aux siennes. Le jour des adieux il m'apporta le billet que ces enfants sans pitié m'ont arraché aujourd'hui. Mon nouveau maitre, un commerçant m'avait acheté pour servir de chaloupe à son grand bateau à voile. Dématée, privée de mes jolies ailes blanches, je fus enchaînée à mon gros et lourd compagnon! Adieu ma chère liberté, Mignon était captive, en vain résistait elle. Enfin un jour de tempête, je parvins à rompre ma corde et après bien des aventures qui seraient trop longues à vous raconter, je vins échouer ici où je vais mourir. Au moins serais-je morte contente, si j'avais eu le lettre de mon petit

Maurice, mais hélàs, elle est au mains de ces enfants et je ne peux rien.

J'ouvris les yeux La barque était toujours à la même place, aussi immobile et muette que jamais.

Mes cousines causaient, assises à côté de moi. Je leur racontai mon rêve et, (idée d'enfant, bien une de mes idées!) je rendis le billet à la barque, je remis exactement à la même place ne gardant comme souvenir de mon rêve que ce mot déchiré au billet: "Mignon".

Tout cela n'est qu'imagination direz vous. Pourtans, restez seul sur la grève, écoutez bien, vous entendiez l'océan qui raconte éternellement l'histoire de toutes les vieilles barques échouées sur ces grèves ou perdues dans ces profondeurs. Il la crie les jours de tempête et la murmure dans les grands calmes.

L. Schwob

Appendix C2 - *Histoire d'une vieille barque racontée par elle-même* - by Lucy Schwob - Published January 1909 in French - English translation

Almost every year I spend a part of the summer holidays by the seaside. My grandmother has, on a charming Atlantic islet, a large house called "Le clos Yvon". My cousins and I meet there each year. Last summer I stayed longer than usual and you can tell that I did not complain about that.

During the first two weeks of August, the heat was overwhelming; the tennis rackets stayed at home but on the other hand the bathing costumes did not. We spent all our time fishing and on the beach. In a cove surrounded by rocks we found an old boat whose keel was deeply buried in the sand. It must have been buried there since the last storm and no ocean wave could move it now.

Often we tried to find out from where it came but the fisherman did not know anything about it......

We played for a long time and, tired, we sat on the edges of the boat. We had put our snack in a little crack at the front, I took it out and saw, stuck between two planks, a piece of paper folded carefully and covered in tarred paper. This explained why it had not been destroyed by the sea.

I unfolded it and read this phrase written by a child "My dear little boat, my Dear, goodbye." One could still see on the ticket something like traces of tears; only seawater, no doubt.

"Mignon" was evidently the name of the boat; one could still read it on the copper plaque at the front of the boat.

Stretched out on the sand in the shade of the boat, we made vain suppositions to explain the origin of the ticket. Little by little my thoughts became cloudy, it seemed that I was alone, far away and that I heard the boat speaking:

"Oh you, great blue waves which gave birth to me, who gave me everything and who took everything away, listen to my story for I am about to die, tell it again to the fish who swim in your depths and to the birds who soar above you, and to the young boats who glide in your surface. I am old, used, finished, but however there was a time when I was the most beautiful boat in my home, the ocean! Built at St Nazaire, I was based at le Croisic. No-one could get ahead of me when

I was skippered by an able pilot. In spite of my fragility I was so easy in the water and so responsive to my rudder that one could easily tackle large waves with me.

An English sailor bought me and I made long journeys with him; he looked after me well and I did my best for him, but I did not like him. Why? you say to me: He thought of me as an inanimate object, with neither intelligence nor feeling and looked after me simply because I was worth money.

After five years, in spite of his care, rust was attacking me and he thought that it was time to sell me and replace me with a younger and prettier friend. We were near the French shore, not far from here and when we headed north-west I hoped to see my native land which I cried for often.

My hopes were not dashed as, after two days of travelling, we reached le Croisic. My joy was impossible to describe! I found one of my old friends and we were able to speak together about the past.

Shortly after we arrived I learned that I was sold to a rich owner of the area. I can tell you that I was overjoyed. Soon I saw my master, who pleased me from the start, as well as his son, a little blonde boy of seven years old. The latter soon had the greatest pleasure of a trip on the sea holding my rudder under the watchful eye of his father. Dear little Maurice! I lived happily this way for three years, but the happiness could not last forever, my master had to leave and despite the prayers of little Maurice they could not take me.

They had to go to a place "where there is no sea" said the father. Maurice cried, as he really loved me, and I shared my tears with his. On the day they left he brought me a ticket which these children mercilessly took off my today. My new master, a merchant, had bought me to use as a rowing dinghy for his large sailing boat. Unmasted, deprived of my pretty white sails, I was chained to my fat and heavy companion! Goodbye my dear freedom, Mignon was a prisoner and resisted in vain. Finally, one stormy day, I succeeded in breaking the rope and after many adventures which would be too long to tell, I ran aground here where I will die. At least I shall die content, if I had the letter from my little Maurice, but alas, it is in the hands of these children and I cannot do anything about it.

I opened my eyes The boat remained in the same place, just as still and quiet as ever.

My cousins chatted, sitting next to me. I told them about my dream and (a child's thought, or even one of my thoughts!) I gave the ticket back to the boat, I put it in exactly the same place, keeping as a memory of my dream just the word torn from the ticket: "Mignon".

All that is just imagination, you say. Nevertheless, stay alone on the shore, listen well, you will hear the ocean which forever tells stories of all the old boats aground on these beaches or lost in its depths. It shouts out on stormy days and whispers in calm weather.

Appendix D - *The Visit to Nantes* - by Jessie Elliston - Published September 1908 in English

I am sure all of you would like to hear something about our visit to our little friend Lucy at Nantes.

We arrived at 10.30 p.m. having left Paris at 4 o'clock exactly. We had our dinner very comfortably in the train, but it was a very hot journey till the sun went down and then it was very smoky, so we were very glad to see the faces of Monsieur Schwob and Lucy waiting for us. We were put into a motor and very quickly reached 12 Place du Commerce.

The house is immense because the office of the Phare de la Loire occupies the first two storeys, and then one comes to an immense library with a splendid collection of English, French and German books which Monsieur Schwob has evidently read for he really seems to know a good deal about everything. He evidently keeps an eye on our English papers and his memory is wonderful.

When we arrived we were taken through this great library and then up another flight of stairs where we came to some large reception rooms, but this was not our resting place. We had to go up higher still and then on the wall of the staircase was painted an immense fresco which Lucy said was the Artist's joke. There was the Loire wending its way to the shore and an immense Phare in the foreground.

Here was our more particular part of the house and here we found two beautiful bedrooms waiting for us which looked most inviting after our long journey and the excitement of arriving. Laurette thought her bed was expecting a Princess to occupy it, but I think mine must have been looking out for a Queen for it was most handsome - beautifully inlaid with mother-of-pearl and ebony.

Everything was interesting to us, as it was all so different from everything we had been used to.

The next day we went to see the Town and the first postcard gives an idea of the place - as Nantes is built on an island connected by bridges.

Then we came back as it was arranged that Monsieur Schwob should take us to the Forêt du Gavre, thirty miles distant from Nantes in his beautiful motor. I am sorry that the only photo I have of it is the one of the Sabotiers.

The next day Lucy took us up a wonderful bridge and from there we got a splendid view of Nantes. You can hardly guess from the post-card how high it is but you must look carefully at the picture and see the curious suspended bridge which is worked by chains from the high bridge. We went across both ways - We started near the house and went down the river in a boat till we came to the bridge station, then we went across in the Pont Suspendu, and then up-up-up those stairs till we got to the top and then we were rewarded.

The next picture gives a view of the Quai Brancas.

Here is a picture of one of the pretty open spaces for which French towns are so much admired, with a very characteristic group of children playing.

The post-card of the Jardin des Plantes does not give such a good idea of it as I should wish, for it was very pretty indeed; and I am sorry that I sent away the picture of the Cathedral which is very interesting.

I must not conclude this short account of Nantes without mentioning the large biscuit factory which, through the kindness of Monsieur Schwob, we were shown over - not only this, we were invited to taste the various biscuits just out of the ovens - and very good they were.

As Monsieur Georges, Lucy's brother, is now serving his time as a soldier, I must give you a little picture of the barracks. He used to dine with us every evening, but he had to be back at 9 o'clock, very punctually.

He was looking forward to finishing his military career, but he was always bright and cheery, and seemed to make himself happy under all circumstances.

In another number I will give an account of our adventures in the car.

Editor

www.ingramcontent.com/pod-product-compliance
Lightning Source LLC
Chambersburg PA
CBHW072212170526
45158CB00002BA/564